# SELF-PORTRAIT WITH A SLIDE

D0769757

# Self-Portrait With A Slide

HUGO WILLIAMS

Oxford   New York
OXFORD UNIVERSITY PRESS
1990

Oxford University Press, Walton Street, Oxford OX2 6DP

Oxford New York Toronto
Delhi Bombay Calcutta Madras Karachi
Petaling Jaya Singapore Hong Kong Tokyo
Nairobi Dar es Salaam Cape Town
Melbourne Auckland

and associated companies in
Berlin Ibadan

Oxford is a trade mark of Oxford University Press

© Hugo Williams 1990

First published in Oxford Poets as an Oxford University Press paperback

All rights reserved. No part of this publication may be reproduced,
stored in a retrieval system, or transmitted, in any form or by any means,
electronic, mechanical, photocopying, recording, or otherwise, without
the prior permission of Oxford University Press

This book is sold subject to the condition that it shall not, by way
of trade or otherwise, be lent, re-sold, hired out or otherwise circulated
without the publisher's prior consent in any form of binding or cover
other than that in which it is published and without a similar condition
including this condition being imposed on the subsequent purchaser

British Library Cataloguing in Publication Data
Williams, Hugo, 1942–
Self portrait with a slide. – (Oxford poets)
I. Title
821.914
ISBN 0–19–282744–8

Library of Congress Cataloging-in-Publication Data
Williams, Hugo, 1942–
Self-portrait with a slide / Hugo Williams.
p.      cm.
I. Title.
PR6073.I432S45   1990      821'.914—dc20      89–49048
ISBN 0–19–282744–8

Typeset by Wyvern Typesetting Ltd
Printed in Great Britain by
J. W. Arrowsmith Ltd, Bristol

*High o'er the fence leaps Sunny Jim*
*Force is the food that raises him.*
                    —old cereal ad.

ROBERT MANNING
STROZIER LIBRARY

DEC 6 1990

Tallahassee, Florida

# ACKNOWLEDGEMENTS

Some of these poems first appeared in the *Times Literary Supplement*, the *Observer*, the *London Review of Books*, *London Magazine*, *The New Review*, *Oxford Poetry*, *Soho Square*, and Poetry Book Society Supplements of 1979, 1981, 1983, 1986 and 1989. Others have been read on 'Poetry Now', and the World Service of the BBC.

ROBERT MANNING
STROZIER LIBRARY

DEC 6 1993

Tallahassee, Florida

# CONTENTS

# When I Grow Up

When I grow up I want to have a bad leg.
I want to limp down the street I live in
without knowing where I am. I want the disease
where you put your hand on your hip
and lean forward slightly, groaning to yourself.

If a little boy asks me the way
I'll try and touch him between the legs.
What a dirty old man I'm going to be when I grow up!
What shall we do with me?

I promise I'll be good
if you let me fall over in the street
and lie there calling like a baby bird. Please,
nobody come. I'm perfectly all right. I like it here.

I wonder would it be possible
to get me into a National Health Hospice
somewhere in Manchester?
I'll stand in the middle of my cubicle
holding onto a piece of string for safety,
shaking like a leaf at the thought of my suitcase.

I'd certainly like to have a nervous tic
so I can purse my lips up all the time
like Cecil Beaton. Can I be completely bald, please?
I love the smell of old pee.
Why can't I smell like that?

When I grow up I want a thin piece of steel
inserted into my penis for some reason.
Nobody's to tell me why it's there. I want to guess!
Tell me, is that a bottle of old Burgundy
under my bed? I never can tell
if I feel randy any more, can you?

I think it's only fair that I should be allowed
to cough up a bit of blood when I feel like it.
My daughter will bring me a special air cushion
to hold me upright and I'll watch
in baffled admiration as she blows it up for me.

Here's my list: nappies, story books, munchies,
something else. What was the other thing?
I can't remember exactly,
but when I grow up I'll know. When I grow up
I'll pluck at my bedclothes to collect lost thoughts.
I'll roll them into balls and swallow them.

# Brave

Jim was lost. I found him in the old nursery
holding a candle to the mirror. 'Look!' he whispered.
'Men with torches are driving something towards us
for the kill. Fetch my shotgun for me, I'll wait here.'

I told him there was nobody there but ourselves
and he put up a shaking hand to feel his head.
'I've been tricked!' he cried. 'That's not the face
of a young brave, it's father after his operation.
Is that why you've shaved off all his hair?'

'Not at all, Your Majesty,' I lied. 'Your Majesty
wears his hair too long for the current fashion.
We want it to look just right for the Coronation.'
'Who cares about the Coronation?' snarled Jim.
'When I've got nothing left on top. Where's my clippers?
Let's see how YOU look with the latest hairstyle . . .'

I had my finger on the bell, but he changed his mind
and smiled benignly round at his courtiers, the old
Mason and Pearson hairbrush upright in his hand.
'I'm sixteen,' he announced, preening imaginary locks.
'Every day that doesn't produce a new poem
is a day wasted for me. What do you think of this one?'

# Self-Portrait With A Speedboat

You wouldn't think it to look at me,
but I was a hot property once upon a time
to my sponsors, Johnson and Johnson Baby Oil.

I reached the final of the 1980
World Powerboat Championship—myself,
Lucy Manners, Werner Panic and the rest.

I was going for the record
of no hours, no minutes, no seconds
and I reckoned I was in with a chance.

I was dancing the *Self-Portrait* along
inside the yellow buoys, nice dry water ahead,
when I started picking up some nonsense

from my old rival Renato Salvadori,
the knitwear salesman from Lake Como,
appearing for Martini.

Renato was chopping up the water with a series
of kick turns and yells and throwing it
in my face like a gauntlet, flak

from his tailplane running off my goggles.
I was pushing the *Self-Portrait*
into a sizeable swell, but I figured the aerofoil

would keep her nose down in an emergency,
the head-rest would account for any recoil
occasioned by overdrive—4g,

that's about four times your body weight
screwing your neck around on corners
and pinning a smile on your face.

4

I looked over my shoulder and saw Werner Panic
hovering and bouncing about.
The three of us hit the Guinness hairpin

at about ninety, sashaying our arses
round the corner post and spraying the customers
with soda water, which they didn't seem to mind.

You can either go into these things tight
and come out wide, or you can go in wide
and come out tight, depending on your mood.

But whereas Werner and myself went into it
tight and came out of it laughing,
Renato lost his bottle completely

and wound up pointing backwards in a pool
of engine oil, miming outrage
and holding out his hands to the judges.

His departure for Lake Como in the relief launch,
clutching his crash helmet
and lucky sombrero mascot,

left me aqua-planing the wash
from Werner's dogleg, covert blue and gold
tobacco logo making me see red.

I'm very fond of Werner, but I'm not about to
hand him the trophy on a platter
just because he smokes Rothmans.

I sat on his coat-tails for a lap or two,
revs going from $7\frac{1}{2}$ to ten thou,
big V8 engine powering along at about a hundred.

I'll never forget his face
as the *Self-Portrait* took off on his starboard wake
and entered the unofficial record books

for ski-jumping—19 feet of aluminium
chucked in a great curve between heaven and earth—
a trajectory to nowhere as it turned out,

but I didn't know that then. As I looked down
on the scene spread out beneath me,
I remember thinking what a fabulous

powerboat atmosphere there was
on the Royal docks that afternoon—
champagne and cigars, jellied eels, a Big Top

with four shows a day, dolphins, a gorilla,
girls in pink leotards, all the fun of the fair.
As I touched down near the pits

my arm came up to say 'thank-you' to my mechanics
for making it all possible.
You can see one of them—Pasquale that is—

returning the compliment at the exact moment
the *Self-Portrait* hits the pier
of the escape basin and vanishes under a layer

of polystyrene blocks, old aerosol cans
and water-logged flyers for the 1980
World Powerboat Championship. That's me

standing up to my neck in dirty water,
holding up a shattered steering-wheel
to cheers from the salvage barge.

# The Missing Years

Highballs were nothing to Jim.
He reached up to them
with an otter's tale called a 'pole'
and found he could touch his toes.
'Jasmine' and 'Cheerfulness'
were stories about his war
and the word for South American love poetry
was another of his tricks. It was Jim
who forced the German surgeons to unpick
a woollen swastika
in memory of a single hour
he spent with April Stanley, the whore.
She had spilled her drink
on the beach at Buenos Aires
and left behind nothing more
than an ice-cube and lemon slice
to indicate where it fell.
The moon stood still on April's left breast,
a star on her right,
Jim's head resting on the star.

# On the Road

A boy came through a door in Opelousas
and stuck two fingers in the air
at a car that was going past
carrying a tourist with nothing better to do
than write down things he saw
as he travelled around America—
Franklin's Skating Arena and Shoe Repair,
End Of The World Sale Of Night Crawlers, dogs
mating in a town called Gun Barrel, Texas,
a boy who stuck two fingers in the air
and went back through a door in Opelousas.

# Dumb Show

The would-be bride is here,
blindfold against the setting sun.
Her heart-shaped bag
has been eaten by her fiancé, the alsatian.
She is armed and smiling
as she stumbles among us with a curse.

Lighting a Greek candle, she curtsies wrongly
and ascends a ladder
let down by one of her assailants.
'Everyone wants to be me!' She cries,
as she dives out of the window
into a barrel of laughs.

# The World of Work

At six the cup of tea is set down.
How the cup of tea is set down.
Quietly, or with suppressed fury.
Jim looks at the face of his wife sleeping
and decides to be horrible.
The bathroom was cold.
He forgot to put on the fire.

He crosses to the window in a rage
and draws the curtains back.
How the curtains are drawn back.
Gently but firmly,
or practically ripped from their hooks?
Jim thinks her room is too hot
and throws the window up.

She wakes in a panic, sitting up in bed.
'Where am I? What am I doing here?'
(She has on her scarf.)
'It's only me, dear. Time to go to work.
Me of course, not you.'
She makes her noise. 'For God's sake
come home with something interesting tonight.'

Jim crawls to his place of employment
and sinks down exhausted at his drill.
What can she possibly have meant?
She's seen the rubber aprons and sheets,
protective floor coverings
and face-guards from Asbestos,
machine maintenance slack.

He's taken her lubricated gloves,
heavy duty cooling agents from Cosmetics,
bone meal from catering.
What more could she desire?
An industrial caution perhaps?
A concrete overcoat? 'Oh yes,
love needs funding,' he reflects sadly.

After work Jim steals a disused
tarpaulin from Bulk Haulage,
a bottle of turps from Ancillary Staff,
a cast-iron alibi from Personnel.
He's going to forgive his wife this time
if it's the last thing he does.
He can hardly wait to get home.

How the table will look
laid with the soiled tarpaulin.
How the glasses will shine
brimming with tomorrow's tears.
'Oh yes, love needs funding, dear,' he remarks,
imagining some in-home gratitude
on the stolen Axminster.

He's out of luck. Mrs Jim
takes hold of the tarpaulin in her teeth
and runs out into the road.
How the turpentine drains into Jim's old
factory work boots and socks.
How Jim rewinds the alarm clock
for another working day.

# The Spell

Now you are far away, it is as if you slept
beside me here again and I watched over you, remembering
the spell I had tried not to break by waking you.
As I watched you sleep, it seemed I had only to reach out
and touch you for you to wake at last in my arms.

# Self-Portrait With A Map Of Ireland

1.

The nurses are asleep
on 'A' and 'B' corridors
as I take the bin-liners from their frames,
tie knots in them
and sling them down the chute
into the garbage skip.
A broken milk bottle
has torn a hole in one of the bags.
Sour milk leaks out on my overalls.

Eight thirty. Here and there in the distance
alarms go off,
the sound of bedsprings complaining softly
under their shifting load.
A cardboard sign
with a moveable clock-hand in the shape of a leg
hangs outside Nurse Bluebell's room,
informing the world
of exactly what she is doing
at any hour of the day.
With the hand on 'Asleep'
she is urging her lover to come quickly now
or she'll be late for work.
I hold my breath and wait.

2.

In the Staff Room, Mr Arnold,
my immediate superior
at England's Lane Nurse's Hostel,
is reading Page 3 of The Sun.
He thinks it's disgusting
the way nurses invite men up to their rooms
then expect staff
to replace their beds for them.

13

'They aren't built to withstand that sort of
behaviour. If they want a bunk-up
they should do it in the car park like the rest.'

He turns their thermostat way down
and keeps them short of toilet paper
so they have to ask him for it
over and over again.
He says two sheets a day
is more than enough for any young girl
to keep herself clean.
They should fold each sheet in four
and make the most of it.
He wipes a gnarled index finger
in the palm of his other hand.

3.
Nine fifteen. Men and boys
are quitting England's Lane by every exit.
Sandra Lewis walks slightly ahead
of her latest conquest, the anaesthetist.
They wait for the lift that never comes.
Through a half-open door
I see Dolores Fenton pinning up her hair..
Outside her room a joke thermometer
indicates 'Late Shift'.
A poster of the moon warns visitors,
'Heaven and Earth Shall Pass Away.
But My Words Shall Not Pass Away.'
We haven't spoken yet.

My job for today
is cleaning out the hood
of the ancient Aga
in the hostel refectory. I want Dolores Fenton
to see me performing this disgusting task

with a good grace
when she comes down to breakfast.
To make her laugh
I am wearing a hard hat and mask.

I lend her my Daily Express
and she asks me to replace her overhead bulb for her
without going through the Office.
Luckily it is my week
to hold the key to the Dispensary
so I get her two 100-watt bulbs
instead of the usual 60-watt one,
a bag of mothballs
and a box of Lifebuoy soap.

No one answers when I knock on her door
so I let myself in and have a look around.
Cups for gymnastics line the shelf.
Pictures of badgers and otters
crowd round the narrow bed. In the bedside table
a packet of Durex Nu-Form
takes me by surprise.
When she comes through the door
I am standing on a chair, fixing the bulb for her.
She checks the switch.
Smiles come on all round.

   4.
This afternoon, Sister Beamish and I
are touring the corridors
on our monthly 'fact-finding mission'.
She knows where to look
for the tell-tale 'map of Ireland'
printed on a sheet,
the different-coloured hair
on hairbrush or comb,
the bristles round the brim of a washbasin.

She sniffs the air like a gun-dog,
scenting the elusive male of the species.
'There's something fishy going on here, Mr Williams.'

We have come to the room
with a cardboard thermometer hanging outside
and a poster of the moon.
Ma Beamish flings open the door
and switches on the light.
I stand to one side,
holding my clip-board and pen,
while Dolores Fenton's boyfriend
struggles into his clothes.

5.
We take our break
and retire to the Office
for tea and Garibaldis from a special tin
depicting the Queen and Duke of Edinburgh
rock 'n' rolling.
Ma Beamish remembers a day
when the Royal Free Nurse's Hostel
was a decent, moral place
and she herself was still young.

'Sister Peele would welcome new arrivals
from Ireland and The North
with a talk in the Smoking Room:
"No men above stairs
under any pretext whatever. If you get the urge
you can always bring yourselves off." '
She dunks another Garibaldi in her tea
and shakes her head.
'We should put a red light up over the door
and call it The Royal Free and Easy.'

6.
Now the girls are coming home
blood-stained and tired from Early Shift,
checking their pigeon holes
and making calls.
'No letter again today. What's got into him?'
The showers come on upstairs,
soap bubbles foam from the waste outlet
where I am trying to unblock the grating
with a piece of wire.
Dirty water spreads out over the yard.

I say it's leaves falling on the roof
that are causing the trouble,
but Mr Arnold insists
it's the used contraceptives
the young doctors fling out of the windows
on Junior Corridor.
He finds a long pink one in the gutter
and holds it up to the light like a connoisseur.
'I wonder where this little baby's been?'
Then he drapes it across the windscreen
of somebody's car: his personal parking ticket.

# The Junior

Elaine hates touching the heads
of the older women in Giovanni's.
She has to cope with styles
that are hardly more than a few strands
clinging to bone as if nothing was wrong.
She feels desperate
until the smell of poor cooking
is drowned by the detergent.
Elaine, 17, is pregnant, but by whom?
She was doing Ruby's hair today
when it started to come away on the comb
exactly like her mother's.
'It wasn't me,' she wanted to say
when the manageress shouted at her
for spilling the dye, but the whole shop
thought how lovely Ruby's hair looked
when it came out coloured pink.
'Who's the lucky fella?' asked Ruby's husband,
putting his head round the door.
But he knew it had to be him.

Now the scissors are laid aside
and the lampshades relieved
of all the pimp-work they have to do
on behalf of the mirrors.
The reptilian manageress
puts on the strip lighting with a frown
and switches out the sign.
Elaine, being junior, has to clear.
She feels dead, but there's nowhere to go
in this shallow lock-up
to escape the stares from the street.
She sweeps the day's clippings
into a corner, remembering a time
when she wanted to work her way up

in Giovanni's as a colour artist.
She picks up a handful of the hair
and looks at it for a moment.
Then she throws it back on the floor.
She must hurry now
if she doesn't want Simon to see her.

# Wow and Flutter

The girl in O'Sullivan's Record Exchange
tips another lousy blues compilation
out of its worn-out inner sleeve
and holds it up to the light for my inspection.
'All right dear?'

Like the back of my head
in the barber's fluttering hand-mirror,
this looks like another one for my collection
that is going to be 'Absolutely great, thanks'—
until I get it home.

# Desk Duty

My desk has brought me
all my worst fears on a big tray
and left it across my lap.
I'm not allowed to move until I have
eaten everything up.
I push things around on my plate.
I kick the heating pipes.

A piece of worn carpet on the floor
proves how long I've been sitting here
shuffling my feet,
opening and closing drawers,
looking for something I've lost
under piles of official papers and threats,
roofing grants and housing benefits.

Am I married or single?
Employed or self-employed?
What sort of work do I do?
Is my house being used for business
or entertainment purposes? (See Note 3)
If I am resident at my place of work,
who supplies the furniture?

I have cause to suspect myself
of deliberately wasting time
writing my name and place of birth
under 'Who else lives with you?'
It has taken me all day
to find something true to write
under 'Personal Allowances'—or not untrue.

I know all about my little game
of declaring more than I earn
to the Inland Revenue—or was it less?
I'm guilty as hell,
or I wouldn't be sitting here like this
playing footy-footy with my desk.
I'd be upstairs in bed with my bed.

# Sonny Jim's House

The cistern groans under a new pressure.
Little known taps are being turned on
in obscure regions of the house,
cutting off the water for his tea.
Jim forwards her mail to the garden, laughing
because he has hidden the marmalade.

At nine they both stay home and do nothing,
out of work. The ring in the bath and the
hacked loaf prove he is on the track
of his elusive wife. Her movements displace
the usual volume of elegant soft porn: face-
creams and cigarettes. Now Jim has razor-burn.

By the end of the afternoon he will have taken
a dozen pairs of sex-oriented shoes
back to her dressing-room. Jim swears
he can still see the funny side of life
in a halfway house where even the shoes
exist in limbo and the hand-rail is loose.

He puts his ear to the door of the study,
rushes in, sees the back of his head.
This is where he sits alone, in coffee-shock,
making lists of women. Photos of his wife
line the walls, reminding him of her.
The cupboard is open. He can't decide what to wear.

When the front door bangs he imagines his wife
has gone out and runs upstairs to look at
her clothes. Blocked by her breakfast tray,
he comes back down again, asking himself
whether the hall is part of the original house
or something to do with the street.

Jim thinks there are two houses here,
each one overlapping the other, like towels,
the spiral stair acting as a kind of hinge
for correct and incorrect behaviour. He stands
for hours on end, rolling his eyes
in soapy water dreams, unable to go up or down.

# Lightly Clenched Fists

Steam clears from the shaving mirror
and a view of eternity presents itself.
The sensation of falling reminds me of my desk.
I wonder what it would be like
if you were walking along
and suddenly you liked Karlheinz Stockhausen.
Bad writing is so like good writing,
don't you think? But never quite enough.
The open notebook which looks like a girl's bottom,
the jet of warm water directed at my trousers,
foam coming up through the plughole for some reason.
Even a piece of wood jammed underneath the door
might be enough to say: Enough!
I have had enough of this.
I am going upstairs to lie down.
But nothing has happened yet.
The quiet period on my own with a good book
goes floating past on a lilo in the sun.
The visit to the farm appears on the horizon
where everything remains to be seen.

# World's End

*to Neil Rennie*

Jim returns to his favourite Carnaby St boutique
circa 1966 and nods his shaggy head.
'Hi, Barry! Hi, Stu! Got the new flares in yet?'
The two Goths behind the counter in Plastic Passion
have heard about people like Jim. One of them
looks out a pair of tangerine elephant loons
left over from his father's 'Chocolate Taxi' scene
and throws them to Jim as a joke. The mildewed hipsters
have purple paisley inserts, patch pockets, studs
and novelty exterior fly-buttons with phalluses.
Jim's eyes shine to see the switched-on funky gear.
He lies down on his back to get into them.

It is Saturday afternoon, as usual in Jim's life.
He wants to show off his new maxi-loons, 3-storey
snakeskin platforms and Mr Freedom T-shirt
with the half-peeled banana batiked on the front
to the in-crowd at the Chelsea Drugstore, demolished
in 1974. He dons his freaky leather hat and shades
and sets off down the King's Road at a leisurely
mile a year, his flares trailing a year or two behind.
By the time they catch up with him, wrapping themselves
gradually round his spindly legs like sails,
the King's Road is deserted. The street lamps don't work.
Jim strikes a match. It looks like World's End.

# In The Seventies

It shouldn't be such a bad day. Tony and I
are delivering copies of *The New Review*
to newsagents in north London.
One of us drives the van, while the other
dashes inside with the invoice book.

Most of the shops in this area
have been taken over by Ugandan Asians
who sit under canopies of soft porn
wobbling their heads at us: 'As you see,
we have so little room for display purposes . . .'

Judging from the miles of overlapping
buttocks and tits, this month's position
is down on all fours in 'the den',
the woman's face crushed in a tiger skin.
'Forgive me, sir,' says the manager,

flicking the pages of our fine but
slow-moving publication. 'This sort of thing . . .'
He pauses for a moment at *In Between the Sheets*
by Ian McEwan. 'If we are honest,
it only hangs around collecting dust . . .'

# Them

How perfect they are without our help,
these limited editions. How even in winter
they seem to shine when you see them,
marching ahead of you, dead set on something.

Their breasts toss things to porters, who bow.
Their knees touch as they get down into cars.
They look so interesting in their savage furs
you can't imagine their parents or their homes
or whether their beds have turn-downs.

Do they sleep, these dreams? It seems impossible
that they go willingly into darkened rooms with men,
there to make love with nothing on,
when they could be walking about in the open.

But perhaps they don't. Perhaps they are really
perched at the mirrored counter where you first saw them,
their jackets only half unbuttoned.

Here comes one now. Can you stop from reading on?
Her heels are bound in such sweet leather.
Her hair has been cut by God, regardless of the fashion.

She knows you are following her,
for she tilts you this way and that in the sun,
catching a glimpse of herself in a new hat
as she turns down Regent Street.

Did she go into Dickins and Jones?
You followed her, but she had left by the other door.
You ran out, but already she was getting into a car
when the man with a little boy came up
and asked you the way to Carnaby Street.

# Sonny Jim Alone

There aren't enough sockets in Jim's room
to accommodate his troubled thoughts.
He runs downstairs in his track suit
and scores a two-way adaptor
from the communal kitchen,
a rubber band from Administration.

Now the hoover and electric toothbrush
spring to life in his hands.
He can almost imagine Cheryl from Hammersmith
here in the room with him,
but the flex from the toothbrush
won't reach as far as the sofa.

Red-headed Cheryl is overjoyed
to have found a position looking after dolphins
so soon after leaving school.
Blonde Elaine, junior colour artist
at Giovanni's Hair Salon,
has a walk-on part as a waitress
in *Bush Babies* with Roger Moore.

Jim reads the folded newspaper
over and over again, his lips moving,
his eyes popping out of his head.
His collection of hairstyles and limbs,
assembled over the years
from Weight Watcher's Weekly and Time Out,
are laid on the sofa under the Anglepoise.
(His favourite has a tyre mark across her mouth.)

As he runs around eating a Mars
and checking the angles of vision

from the houses opposite, a dozen pairs of eyes
seem to follow him round the room.
Supposing someone came in? What would he say?
Where would he put everything?

Tantalizing Tina from Tonbridge
has got it all figured out.
She used to be an accountant
with a firm of market researchers in Cosmetics
until she put two and two together
and came up with herself.

Jim feels exhausted by so many new concepts,
but he catches sight of her exercise bike
and imagines her riding over a cliff.
A light under the door
finds him flying through the air
desperately clinging to Tina's breasts
while trying to forget about her at the same time.

As he doubles up, the careful arrangement
of underwear and smiles,
propped on the back of the sofa,
collapses and Jim comes face to face
with George Maccaree, fittest fattest Briton,
52 stone of solid muscle, a seven-foot girth
and short, glossy hair which he's pictured grooming.

'I was just putting up these foxhunting prints
and hoovering the . . .'

# One Pilot, One Crew

You're walking home late at night after a party.
It sounds like a possible first line
and you write it down in your address book.

On the opposite page a girl's name stands out,
Ari-Non or Nori-An, the names of one or two
Malay nurses you remember meeting,

or that of the Malay airline pilot
who took you, as far as you remember, in his car.
You're wondering where to go from there

when you fancy the figure of a nurse
keeping pace on the opposite side of the street,
Nori-An or Ari-Non, stopping when you stop,

or bending to tie her shoe. You try the line
'How about making us both some coffee?'
But the nurse has heard that somewhere before.

'No milk, no coffee,' she replies.
'You've got some water, haven't you?'
'Sure. You want glassawatter?' She has opened a door

on the usual bed-sitting room
where two double beds have been pushed together
and two Malay boys lie asleep in one another's arms.

'Whose idea are they?' you ask, pointing to the boys.
'I dunno,' says the nurse. 'One pilot, one crew.
Wassamatter, don't you like Malay?'

# Couples In Love

Couples in love cock their heads about
and make small, peculiar facial movements
as they gaze into one another's eyes.
Their facial muscles become taut,
their skin becomes flushed or pale,
their eyes become clearer or brighter.

Other minuscule changes take place
within the eye itself, a fact recognized
by oriental jade dealers,
who veiled their eyes during bargaining
to hide their excitement
and avoid any increase in the asking price.

# Daffodils

I remember drawing back the curtains
and seeing my neighbour Georgie Windows
for the first time.

He was standing on the window sill
polishing the air of our open window
in 4/4 time

and trying to look in.
I didn't realize then
that he was the happy genius of our street.

He worked at first floor level.
While his wife went along
knocking on front doors,

Georgie made himself known
to the couples upstairs in bed.
He'd been wondering, he said,

whether there was anyone
living here any more,
or whether we were hibernating.

He used to take his motorbike to Wales
at about this time of year.
We knew it was Spring

when Georgie swore in Welsh
and took off into the blue, his eternal
wife strapped to his back,

his ladder to heaven. He came home early
this time last year,
having left her alone there.

He'd ridden all night
and made it home in record time,
just in time to go to work.

She was waiting on the doorstep for him,
the house all clean and welcoming,
his favourite daffodils in every room.

# Jim's Dance

Now Jim lives in squalor with his former wife,
or thinks he does. He never sees her any more,
unless she is furious, or pregnant,
and even then she uses her hand as a veil
when they pass one another in the hall.

Jim doesn't mind. He thinks of these meetings
as the steps of a dance he's learning,
where everyone closes their eyes for a moment
as they come forward to bow. He closes his eyes
and bows to her image on the stairs.

Jim's wife is hardly more than a word of command
to him now, a shopping-list pinned to his overalls.
He looks for her in the old nursery
and in the bar, knowing that if he catches her eye
it will be bad luck all day.

# Voice Over

There comes a point in this song
when I hear your voice
calling my name outside the door
and for one moment
I think you are still here,
terror and desire competing
for my suddenly pounding heart.

# Toilet

I wonder will I speak to the girl
sitting opposite me on this train.
I wonder will my mouth open and say,
'Are you going all the way
to Newcastle?' or 'Can I get you a coffee?'
Or will it simply go 'aaaaah'
as if it had a mind of its own?

Half closing eggshell blue eyes,
she runs her hand through her hair
so that it clings to the carriage cloth,
then slowly frees itself.
She finds a brush and her long fair hair
flies back and forth like an African fly-whisk,
making me feel dizzy.

Suddenly, without warning,
she packs it all away in a rubber band
because I have forgotten to look out
the window for a moment.
A coffee is granted permission
to pass between her lips
and does so eagerly, without fuss.

A tunnel finds us looking out the window
into one another's eyes. She leaves her seat,
but I know that she likes me
because the light saying 'TOILET'
has come on, a sign that she is lifting
her skirt, taking down her pants
and peeing all over my face.

# Day Return

Your work up north takes longer than you think.
You have to have a drink with a man
who doesn't have a home to go to
and lets his hand fall heavily on your own
in explanation. The train he finds for you
is a mockery of a train
and keeps slipping backwards into wartime obscurity—
blackouts and unexplained halts.

Is it really the same day
you arrived in that northern city in a clean shirt
and walked through sunfilled streets
with half an hour to kill?
You sit in your corner seat
holding your ticket in your hand.
Someone asks if there is a buffet car on the train
and is told he must be joking.

# Creative Writing

Trying to persuade about fifteen
Creative Writing students (Poetry)
to put more images into their work,
I was fiddling in my pocket
with an old contraceptive packet,
put there at the start of the course
and long since forgotten about.

*If you don't mind my saying so*
*you seem to see everything*
*from the man's point of view*
*exactly like my husband.*
*What happened to women's poetry*
*in the last two thousand years?*
*What about Sappho?*
*What about Sharon Olds?*

The foil wrapper of the Durex Gossamer,
weakened by hours of friction,
gave way and my fingers found themselves
rubbing together in a mess
of spermicide and vaginal lubricant.

# Jim Flips His Wig

The first white hair was the first
screw coming loose. He took no notice.
He smoothed it down with his brush.

Now a whole gang of little pubic horrors
is springing from his skull at all angles,
putting up their hands in class
to ask Jim what they're for.

Jim doesn't know. He cuts them short.
He thinks he'd look more intelligent and smart
without any hair at all, so he pulls it out
in handfuls and throws it away.

As he turns to admire his handiwork in the glass,
comic book mainsprings and bells
burst from his head like an overwound
alarm clock, bringing the house down.

*See how his long dark hair*
*conceals a curly fright-wig underneath.*
*What a great idea to come as Harpo Marx!*

# Self-Portrait In The Dark

'Are you a member, sir?'
Of course I'm not, so I have to pay in full
for the pleasure of entering some former gents
where even I can tell
fulfilment isn't waiting
in the smell of beer and men.

Is it worth it, cruising the streets for fun,
johnnies in your pocket,
a spare crash helmet slung on the handlebars?
If I don't slide under a bus in the rain,
the bike breaks down
or I'm stopped by the cops again.

My room is comfortable, warm and bright.
Why can't I stay in it and work?
When darkness falls, like some excuse from God,
I weaken inwardly, I melt
for little sighs and looks,
for words that don't make sense.

'Desire, desire . . .' How does it go?
'I have too dearly bought . . .'
When someone asks me for a light, I jump
six inches in the smoke-filled air
and come down with a bump. What am I doing here
in The Borderline at half past two?

The later it gets, the younger everyone looks,
the longer ago. The girls coming through the door
are probably children by now
dropping by on their way to school.
For what they are and for what they do . . .
my body drags its feet.

When I see a cigarette in my hand
I know I must be drunk.
I watch a girl in underwear and lace
being drawn back and forth on a string
which runs from the ladies down a flickering stair
to the dance floor below.

She reels herself in across the dark pools of eyes
and back up the stairs again.
I feel the heat of her body on my face
as she passes in front of me.
I ask her to dance and she rolls her eyes
because I am so weird.

She points a little pointy finger at the stage
and brings it to her lips.
The music stops, marooning me.
Something called 'Jungle Boy'
is dragging its congos forward like a ball and chain.
*I think I have not a right feeling towards women.*

# The Best In The World

You girls whose talk is all of Pop,
you're showing off to us
in your halter-tops and slacks.
Your looks announce with such mild cruelty
that this is all there is
and all there ever was
of happiness in Young America.
'It's the best-in-the-world!' you say
when you stand your boyfriends up
just to be here tonight,
revolving, alone, in the spotlight.
'Try it, you'll like it,' you say,
'It's the Real Thing.'
When you dance in close
you turn your backs for fun:
pop heels, pop curls, pop eye-shadow.
You know what's going on
is the best in the world for us.
(You don't say yes just yet,
but you're fixed up for sure.)
You lean towards us and say,
'Perfection would be . . .'
You say 'Purr-fection' like the disc-jockey,
flicking back your hair.
You aren't around to tell us any more.
You're moving on in Young America.

# Desire

Arching perfectly-plucked eyebrows
over blue eggshell eyes
she tells me it is possible in her country
to go all the way
from Viipuri on the Gulf of Finland
to Jisalmi, far inland,
on little steamers
which thread through channels in the rocks
and forested islands.
Moving her hand through the air
she describes how certain rivers and lakes
cascade into other lakes
in magnificent waterfalls
which provide all the electricity for Finland.

# Sonny Jim On Parade

If this is Jim, marching up and down
in his room, swinging his arms up and down
and drilling his men,
why do horse-hairs, curly-wurly things,
nothing like his own thoughts,
break free from the surrounding calm
and pop up like question marks
on the ends of his commands?
'Left wheel?' 'Right wheel?' 'Attention?'
Jim shakes his head from side to side,
as if to get rid of some irritating
chattering noise from the ranks.
'By the front. Quick march!'
Jim takes the salute with his comb.

# Lost Lines

Even before you turned your head
you knew it was one of them—
neither woman nor man
but one of those images
that sweep through revolving doors
into thinner air,
leaving a draught where you stand,
a shiver down your spine.

Your life isn't long enough
to follow where they are going.
You will come to an end, die
and be forgotten about
and they will be tapping a little foot
on the other side of town,
where someone half turns their head,
knowing it is one of them.

# The Trick

If only the trick were letting a record
spin over between your hands,
setting the needle down
and returning to your seat.

If only it could be done
by getting comfortable again,
your head leaning on your hand,
your eyelids drooping.

If only it would help in some way
to gather your papers in your hands
and bang them on the table-top
to get their edges aligned.

You could hold all your papers in one hand
and splay them out like a fan.
You could riffle through them occasionally,
as if you were looking for something.

When your papers fell from your hand
and scattered round your chair,
you could sit for hours on end
without so much as a move.

# Everyone Knows This

Everyone knows this—
the tiny, insane voluptuousness
of writing a cheque, ticking it off
on a list, retiring to the sofa.
Something like a report or a letter
hangs over your head, books and magazines
pile up, free offers
of Kodachrome, conditioners, tea-bags,
holidays on Mount Everest.
You lay down your pen for a moment
and somehow or other
never pick it up again.
Your handkerchief falls out of reach.
You get to your feet, having accumulated
one nice and one nasty thing to do
and do the nice thing first.
You open the fridge door and stare for a while
into that little lighted world
with its air of hopefulness.
You'd like to go out, but it isn't raining yet.

# The Offence

According to Jim, it all began innocently enough
in a wood near the caravan site where the two boys
had been holidaying with their grandparents.

Jim was practising with a punchball
when out of the bushes rushed the two brothers
wearing warpaint and feathers and uttering cries.

They persuaded Jim to take part in a game
of Cowboys and Indians, warning him
that he would be scalped if they took him alive.

He was duly captured and tied to a tall tree,
where we found him next morning, naked
and weeping and suffering from exposure.

His head had been shaved. His face and body
had been smeared with lipstick. He told us about it
in sign language and gibberish.

After carrying out extensive enquiries in the area
we could find no trace of these brothers,
their grandparents, or their holiday caravan.

In the lonely spot described to us by Jim
we found only his tent, a simple Wigwam type,
in which he had been living alone for several weeks

on tins of tuna fish. Among the few items left
lying about, we found various articles of make-up,
lipstick, a mirror, and a pair of hair-clippers.

# Autobiography

They had a knobbly knees competition long ago.
I thoroughly enjoyed myself.
I didn't really.
I hated coming home and finding the words
'bandaged' and 'bloody' lying there.
I ran upstairs to fetch a mop
and my body fell back on the bed.

Descending against my will,
I blocked my own path. I obscured the view.
Books balanced on my head. I seemed to be astride
a hobby-horse of reference works,
*Proverbs and Maxims of All Ages*
flicking its pages in my face
to simulate the passage of time.

I shuffled down the passage with a tray
and hit my head on something hard.
I came to a standstill in the hall
and all my possessions
went hurtling past me down the waste chute.
I stood out of sight behind a curtain,
crying and laughing to myself
as a dust cart crept along the street.

# Old Scene

*Jim*: No perfumes, nurse. These oils drown my head
with their clamour of marriages and mourning,
their oozy lava nibbled at by flies.
My hair is no bunch of flowers stuck in a vase,
exuding forgetfulness. It laps my body
in hot smells, as if some animal breathed on me.
I lie here stiff with horror at its caresses,
while lions watch the listless wreckage of my innocence
drop down through my eyes. They ease aside
my garments' chastity. They nuzzle at my knees.
Help me, nurse, bring this wild mane of mine
to its senses, or I'll die. It makes me faint
raising my arms above my head in a kind of surrender.
A hundred brushstrokes, please.

*Nurse*: Poor victim on the altar of your fate!

*Jim*: You whisper how the white stalk of my body
must one day burst from its scented shroud
and flower in blue air. Were you not about to touch me,
there where the towel falls across my thighs?
Calm, nurse, the trembling of your senile flesh.
Don't you know I'm half in love
with the horror of my virgin state? It thrills
and fascinates me still. It makes me whole!
I'll live forever in the shock my hair inspires.
I'll stand alone on this monotonous earth,
feel on my useless flesh the sunset's chill.
I'll crouch like a reptile on my parchment bed,
swaying my neck back and forth, while in the glass
my hair's metallic sheen hoards my nakedness
and wild beasts howl . . .

*Nurse*: Sad flower! Before you decide to offer yourself
as a snack to such fierce animals,
your wintry nurse begs leave to suggest

51

you get on up them stairs and clean your teeth.
I was turning your mattress the other day
and found this little book called 'Mallarmé'.
Perhaps you'd care to explain? Or would you prefer
to embrace the hidden doom endlessly awaiting you
in the spitefulness of skilfully dazzled caverns,
O royal personage revered by lions,
O Jim of diamantine gleam?

*Jim*: Relight the candles, nurse, whose red wax weeps for me.

# Saint Jim

Jim sits in glory in his home-made chair,
one hand slightly raised, holding a ten pound note.
His face and moustache are smeared black.
His widow's peak is visible under the brim
of a stetson. Bunched at his throat,
a dozen gaudy ties, the gift of petitioners.

On the walls of the reception area, a Marlboro ad,
naked women, a plaque thanking Jim
for a miracle. 'If you visit, please make some
donation to my needs, or help with the cleaning.'
I hold his gloved hand in mine
and whisper how handsome he is looking.

He makes no reply. His eyes follow me round the room
as I light candles or scrape wax from the floor.
I tap ash from his cigarette and place it
in a polythene bag, for everything in the world
is Jim's and has to be put away.
He turns a page of Playboy magazine.

His bottle of gin he keeps in the Air France
flight-bag slung on the arm of his chair.
'What am I supposed to do, let myself
be covered with earth, seeds and moss? Leave behind
nothing but my jawbone and teeth, a little mound
with flowers on top and nothing underneath?

I'd rather stew in my own juice.' I tip him back
and pour it down his throat. It won't be long
before he is singing one of the songs from *Kismet*
or *Guys and Dolls*: 'If we only had a lousy little grand
we could be a millionaire.' Or complaining about the service
in this 'once great hotel'.

I remove the plastic basin from his chair,
take off his nylon suit and haul him up
into the roof, where the talk goes on like that
far into the night. 'What am I supposed to do?
Burn? Shriek? Turn into a brand? Blackness?'
The empty bottle goes in the filing cabinet.

# Self-Portrait With A Slide

Assembled with me on the long slide
are breakfast, lunch and tea,
their preparation and consumption by me
and the washing up afterwards
stacked and waiting in the sink.
I have to go down the slide, balancing a tray
both full and empty, hot and cold,
looking both hungry and satisfied,
bored, excited and tired. I stand at the top
in pyjamas and dressing gown.
I mustn't forget my mat.

Mornings are dizzying, looking over the edge
at a stub of pencil
lying on the breakfast table
after I have cleared away the things.
I have been standing on the landing until now,
indicating my face
with a slack index finger,
not wanting to hurt myself going down.
The monitor taps me on the shoulder: time to go.
I rise to my toes
and throw off my dressing gown.
I raise one hand in the air.
Pieces of coastline and sky are dragged across my sight
as I swerve to avoid the bathroom.
We're off, I suppose,
if a wave of homesickness is anything to go by.
I remember my bedroom with a sigh.

Now the long slope of the day
pitches forward slightly,
causing me to stumble.
Papers and books pile up behind my back,
anxious to pass me and get on.

Washing tangles my feet.
The sofa, the horse ride, the supermarket
nudge and buffet one another,
lurching to one side. I come out of a spiral
clinging to the handrail for my life.
I overtake my stereo, stuck in the last groove
of *Lift to the Scaffold*.

My eyes are cast down,
as if from modesty or embarrassment.
My half-closed hands
lie on the table in front of me
where I can see them. From the way I am sitting
staring at a sheet of paper,
something would seem to be the matter.
Perhaps I am ill?
Or the temperature of my pen won't come down?
I lean over myself
with a concerned expression on my face,
as if I am visiting.
I think of something kind to say.
*How am I feeling today?*
*What would I like to eat?*
My pen moves jerkily over the paper
for a moment, like the needle of an instrument
for recording brain-life.
From the other side of the street
I look like someone writing. My head comes up
as if I am pausing to think.

I've changed a lot in the last five minutes.
I'm not here most of the time.
I'm over here behind the door.
I'm willing to turn a blind eye
to some of the things I do,
but I like to know where I am
in case I have to go out.

It's sad to see me going so far away all alone,
but I have my permission to come back
whenever I like
and start again.
I can't remember where I was.
I forgot to mark my place.

Is the stub of pencil where I left it,
arrested in mid-flight?
If I lean out,
I can touch it with my finger as I pass.
I can't get hold of it. One false move
and it drifts out of reach
behind the breakfast tray, vibrating uselessly.
If I could nudge it into the upright position
I might feel able
to describe the kind of grip
that would hold it still for a moment
while I concentrate.
My eyelids droop
and I have a more interesting experience
for a few seconds, working in plasticene.

Now everything is slipping through my fingers
into the next-door room
where I am trying not to slide down to the kitchen
for a bite to eat.
Can you feel the wind brushing my face
as I shoot across the kitchen into the hall?
My hair flies out behind me,
making me look free,
but I am in the street, alas,
wasting time shopping. I dig in my heels
and my hair flies forward in my eyes. Dogs bark
as I peer into my house while I am out.

I thought I had found a way down
through the system of snacks and mood changes
that constitutes an average day
on the slide,
but I have lost my footing
in the loose hours before tea.
I veer from side to side.
I throw my tray in the air.
So much rubble has broken loose
since this morning began so promisingly
with a friendly push from behind
that I scramble on all fours
across an escarpment of coffee cups.
I cling to the tablecloth.

Is this The End coming up to meet me
waving excitedly? I reach out my hand
to touch the patch of sunlight or yellow lichen
on the bedroom window-sill—
shadowy patches of fungus,
or the yellow primer showing through?
It's hard to tell
when the pencil hovers in mid-air
leaving only a blur.
I thought I had reached ground level
and could shake the Champagne bottle
to a celebratory fizz,
but this looks like the start of something new.
The monitor gives me a push and down I go,
uttering involuntary cries.

# Deserter

The days hang back. They come at me
in shock-waves, like bad news. They dawn so late
I sometimes think I missed one in my sleep
and lie here counting them. From where I lie
I can see them parading past my window
like soldiers going to war. White curtains
drawn back and forth across my sight
are handkerchiefs in the hands of girls
waving goodbye to their loved ones.

I see them coming round again,
accusing me with their blood-stained uniforms
of having betrayed them. Memory falls
like a too bright light on my surroundings.
Motes of dust, revolving in the first rays of sun
are all it takes to make me feel afraid.

# Bath Night

A nurse kneels on the floor of the bath house
pulling loose Jim's protective underclothes.
'Washing you,' she murmurs,
touching the marks left by the laces.
'Remember now. Washing you.'

Jim stands up very straight and tall,
his eyes screwed shut.
His toes grip the edge of the bath mat.
'Washing you,' he repeats after her.
'Remember washing you.'

The nurse picks up Jim in her arms
and lets him slip out of the towel
into the disinfected water. His wasted legs
loom to the surface like slender birch trunks.
His feet stand up like pale stalks.

He wheels at anchor now, in his element,
and sometimes he floats free of the dry world
in that narrow white boat
that is going nowhere, wreathed in steam.
And sometimes he remembers her.

'Washing you,' he murmurs, as the green water
laps his body. 'Remember washing you.'
His eyes are screwed shut.
His arms are folded across his chest
as if he is flying into himself.

# OXFORD POETS

Fleur Adcock

James Berry

Edward Kamau Brathwaite

Joseph Brodsky

Michael Donaghy

D. J. Enright

Roy Fisher

David Gascoyne

David Harsent

Anthony Hecht

Zbigniew Herbert

Thomas Kinsella

Brad Leithauser

Derek Mahon

Medbh McGuckian

James Merrill

John Montague

Peter Porter

Craig Raine

Christopher Reid

Stephen Romer

Carole Satyamurti

Peter Scupham

Penelope Shuttle

Louis Simpson

Anne Stevenson

George Szirtes

Grete Tartler

Anthony Thwaite

Charles Tomlinson

Chris Wallace-Crabbe

Hugo Williams

*also*

Basil Bunting

W. H. Davies

Keith Douglas

Ivor Gurney

Edward Thomas